DIRTY BOW WOW

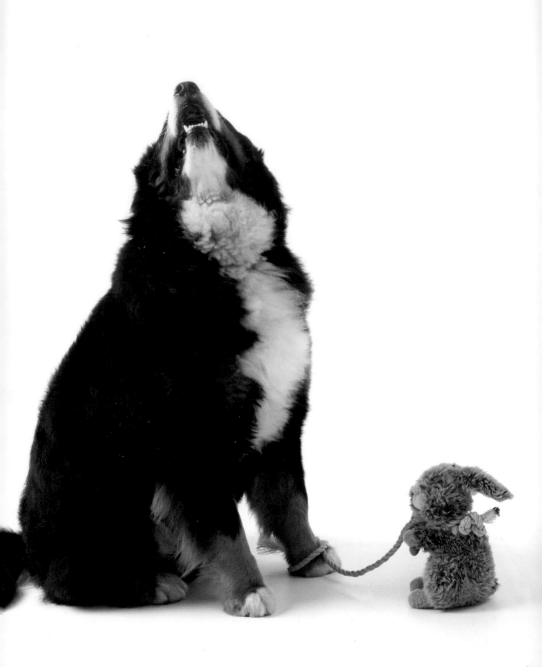

DIRTY BOW WOW

A tribute to dogs and the objects of their affection

Cheryl and Jeffrey Katz

PHOTOGRAPHY BY Hornick/Rivlin

TEN SPEED PRESS
Berkeley

Page 2: Hogan (Bernese Mountain Dog) and Rabbit
Hogan is a good natured soul. True to the traits typical of his breed, he is a loving and dedi-cated companion. A bit shy and reluctant around new people, Hogan had to be cajoled onto the set to have his picture taken. But once he was comfortable and sure he was among friends, he couldn't have been more of a ham, happy to be tethered to his best buddy, Rabbit. The more his audience cheered him on, the happier his howl. What a beauty!

Published in the United States by Ten Speed Press, an imprint of the Crown Publishing Group, a division of Random House, Inc., New York.
www.crownpublishing.com
www.tenspeed.com

Ten Speed Press and the Ten Speed Press colophon are registered trademarks of Random House, Inc.

Library of Congress Cataloging-in-Publication Data
Katz, Cheryl (Cheryl B.)
 Dirty bow wow : a tribute to dogs and the objects of their affection / Cheryl and Jeffrey Katz; photography by Hornick/Rivlin.
 p. cm.
 1. Photography of dogs. 2. Dogs—Equipment and supplies—Pictorial works. I. Katz, Jeffrey (Jeffrey P.) II. Title.
 TR729.D6K38 2009
 779'.329772—dc22
 2008041474

ISBN 9781580089661

Printed in China

Cover and text design by Nancy Austin
Cover photography by Hornick/Rivlin

11 10 9 8 7 6 5 4 3 2

First Edition

For our dear friend Nora Devlin,
and our extraordinary children, Fanny and Oliver

CONTENTS

INTRODUCTION

When we were writing *Dirty Wow Wow*, a book celebrating the threadbare love objects of childhood, it seemed that every child we encountered was accompanied by a well-worn bunny, blanket, or bear. One evening, a year later, we were heading home from our design studio when we passed the dog park in Boston Common. We stopped to watch the dogs run and play until dark descended. Leashes came out, people called or whistled, and the dogs came running. Nearly every dog had a stuffed animal, squeaky toy, dirty tennis ball, filthy Frisbee, or frayed rope toy in their mouth. The idea for *Dirty Bow Wow* was born.

This got us talking about the dogs we had loved growing up. Jeffrey's family pet was, as poodles used to be called, a miniature *French* poodle named Pierre. Pierre was Jeffrey's mother's pride and joy, and like Jeffrey's mom, Minnie, Pierre was stylish, well coiffed, and alarmingly manicured. Though Pierre didn't have a standing Saturday morning beauty salon appointment like Minnie did, he did go to a pooch parlor on a regular basis. Just when Pierre would get scruffy to the point of almost looking natural, Jeffrey and his sisters would return home from school to find a powdered and perfumed Pierre, head and tail punctuated by pom-poms, toenails painted an embarrassing shade of pink, with a matching ribbon around his neck. The effect was meant to emulate a pedigreed champion ready for the show ring, but the result ended up with Pierre looking more like a life-sized figurine. Poor Pierre.

Cheryl's family had a mutt—a cross between a Beagle and a German shepherd, as near as anyone could guess—named Happy. As her name suggests, Happy was given to Cheryl's sister Leslie on her fifth birthday in the hopes that Happy would become a playmate for her. The family had recently moved from the city to what seemed like an empty suburban neighborhood devoid of other children. However, much as Cheryl and Leslie tried to win Happy's affection, the dog preferred their dad, Joe. Joe took Happy for walks in the woods behind their house, fed and bathed her, and made sure that Happy had a bowl of corn flakes every morning for breakfast. Probably just as well. Had Happy spent much time playing with the little girls, sooner or later she would doubtless have succumbed to their favorite game of beauty parlor. Happy, too, would have ended up with an extraordinary hairdo and pink nails.

Alas, neither Pierre nor Happy had a Dirty Bow Wow, so during the photo shoot for this book, we were fascinated as dog after dog cavorted with their favorite object. We were delighted when we saw Pepper's joy when Pink Elephant was in sight, Bliss's true bliss when Orange Horror was brought out of a bag full of Dirty Bow Wows, and Seamus's pure pleasure as he retrieved Bucky.

After spending many wonderful days in Rick and Sandy's studio with the dogs and their toys, it made us wonder what our long-gone pets would have adored. What if they had had the good fortune to have been attached to something that gave them as much happiness as the stuffed monkeys and bears and gorillas gave the dogs that we photographed? Pierre, the French poodle? He probably would not have settled for anything less chic than, like the toy poodle Annie Goodman, a satchel full of treasures. Happy? She was a simple soul. Like the French bulldog Diesel, she would probably have been attached to nothing fancier than a discarded water bottle.

And so it was with memories of Pierre and Happy that we embarked on this book, an effort to capture all these beautiful, good-natured creatures with the things that make them happiest—their Dirty Bow Wows.

AMOS and Quacking Duck

*A*mos and Quacking Duck spent their youth together engaged in a series of high jinks. As his name suggests, Quacking Duck was not the silent type, which, given his rambunctious partnership with Amos, was a blessing. When the two invaded the next door neighbor's backyard—the aroma of barbecue too hard to resist—Quacking Duck's distinctive voice helped Amos's family locate just where the two rascals had gone. Now, as they grow old together—Amos a little slower and grayer and Quacking Duck headless—their escapades have been scaled back a bit. They can often be found reminiscing about the good old days and the pleasures of absconding with the occasional burger, ketchup and mustard not necessary.

Golden Retriever

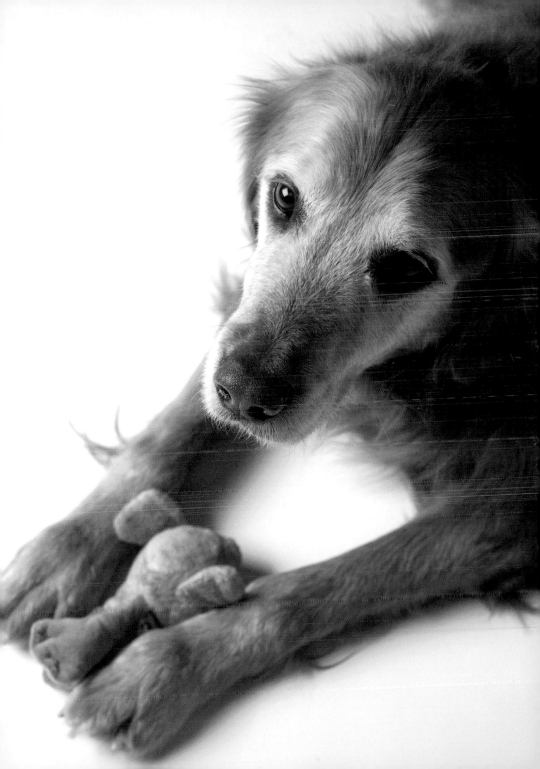

ANNIE GOODMAN
and Pink Purse

*W*hat French-American princess goes out without the perfect fashion accessory? Certainly not the trendy Annie Goodman. In fact, the nine-year-old canine fashionista goes to great lengths every day to excavate Pink Purse from her extensive collection of couture accoutrements. Annie rarely leaves home without the chic tote, a gift from her Aunt Pam, which holds an interesting yet practical assortment of items, including a collapsible water bowl, a leash (pink, of course) and a brush. Attention to appearance is every urban poodle's prerogative.

Toy Poodle

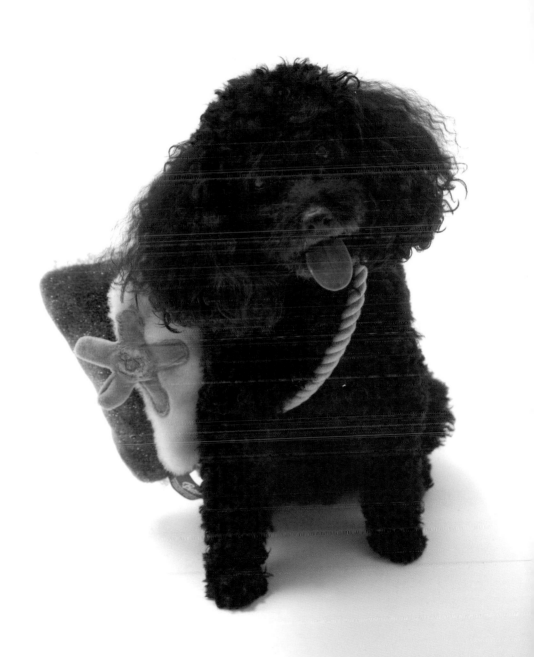

BEAUREGARD aka BEAU BEAU and Big Red

*B*eau Beau and Big Red have been friends from the start. No fair-weather friendships for this diminutive dachshund. No ball, bone, or bear (and there have been many) can turn his head or bring two-year-old Beau Beau such bliss. There is only one thing that excites him more than playtime with Big Red. An energetic romp with his family in the verdant meadow that surrounds their house is an irresistible treat. During these extensive nature rambles, the always thoughtful Beau Beau leaves his beloved Red indoors. For as much as Beau Beau would love to share his love of the outdoors, his short stature makes searching in the tall grass for Red something of a challenge.

Dachshund

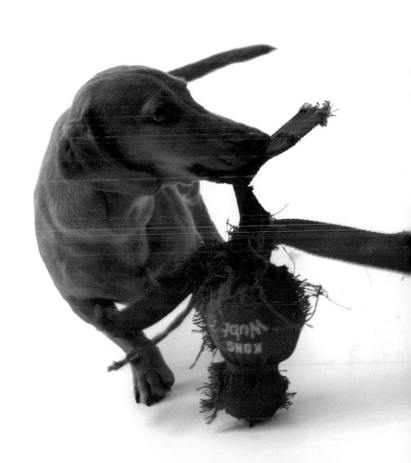

BELLE and Quilt

*B*elle had been homeless, hungry, cold, and on the run when she
was picked up and placed in a foster home, only to escape again after just
a few weeks. It was another month and a half of living on the streets during
a frigid Maine autumn and winter until Belle was finally found and taken in
by the Animal Rescue League of Boston. Having survived a series of brutal
December snowstorms that left her with a frozen paw, she was being patiently
nursed back to health by caring volunteers when Astrid came to the adoption
center and took Belle home. Astrid not only provided a warm and loving
household for her peripatetic pal, but a warm and cozy quilt as well. Though
Belle is a roamer by nature, she now finds enough comfort living with Astrid to
keep her close to home.

Beagle Mix

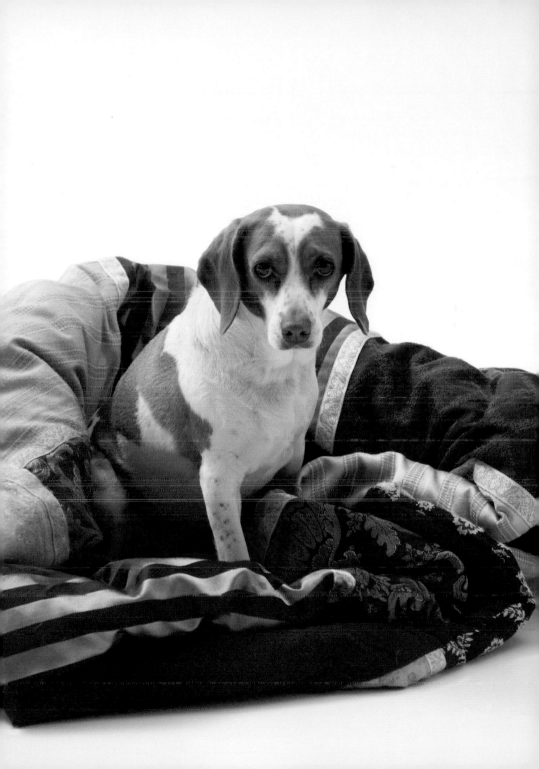

BLISS and Orange Horror

*N*ames can be misleading. Bliss was terribly abused early in his life. Found in a gutter, he had been sliced with a machete and left for dead. Bliss was nursed back to health by Pamela. He's doing pretty well these days, the only residue of his terrible past manifests in his being shy, skittish, and easily spooked. Some of the credit for Bliss's recovery may be due to his best buddy, Orange Horror, who is indeed orange, but hardly a horror. It's ironic that after all this young dog has been through, an object named Orange Horror would bring Bliss such, well, bliss.

Mixed Breed

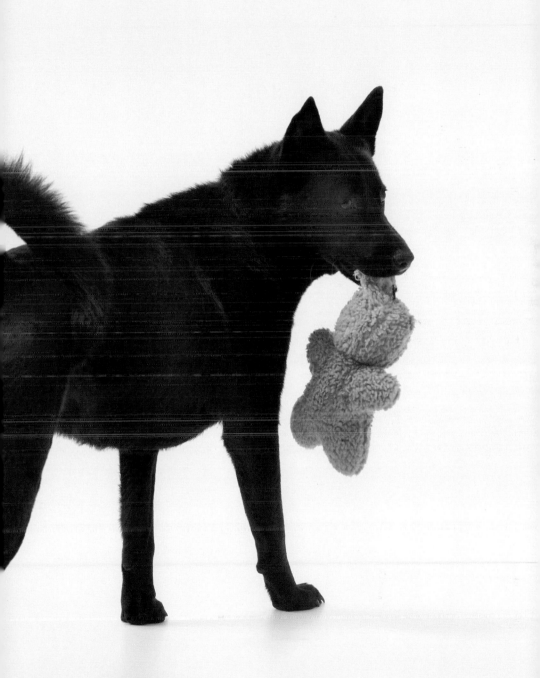

BUGSY and Bear

*W*ho could resist a face like this? Certainly not Bear. Who wouldn't love Bugsy's cute-as-a-button nose, expressive mouth, and velvety coat? As if these traits weren't reason enough to fall head over heels, consider the adage—the eyes are the window to the soul—and you'll understand why this smitten teddy was swept off his paws by the four-year-old pug. The two have become inseparable. Some might say it was love at first bite, although, remarkably, Bear's fur, features, and appendages have remained almost entirely intact—a testament to Bugsy's gentle manners and generous nature.

Pug

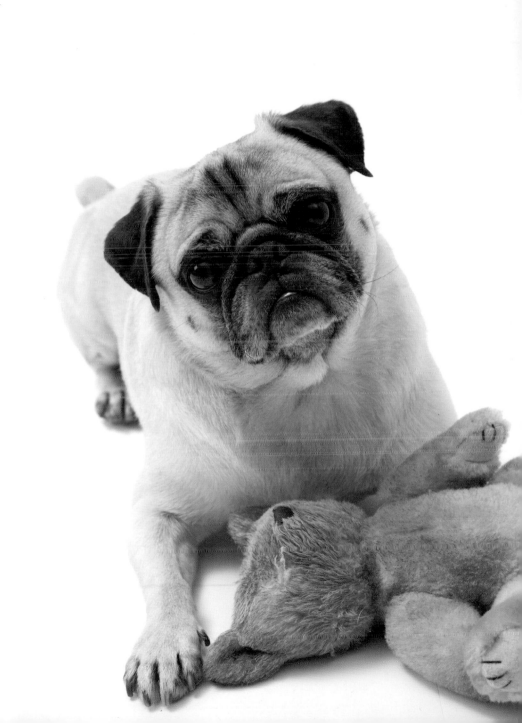

BUSTER and Soccer Ball

The Lenox Massachusetts Youth Soccer league is short one ball, thanks to Buster. Like many of the young athletes, the soccer field is his favorite place to play. One day a couple of years ago, Buster emerged from the brush at the edges of the field with a ball that had either been forgotten or left for lost after a game. You might think that the rule of finders-keepers would have been at play here, but not so. "I promised to return the ball just as soon as Buster was done with it," said Tom. But given how much fun Buster has had with it, that may not be any time soon.

Labrador Retriever

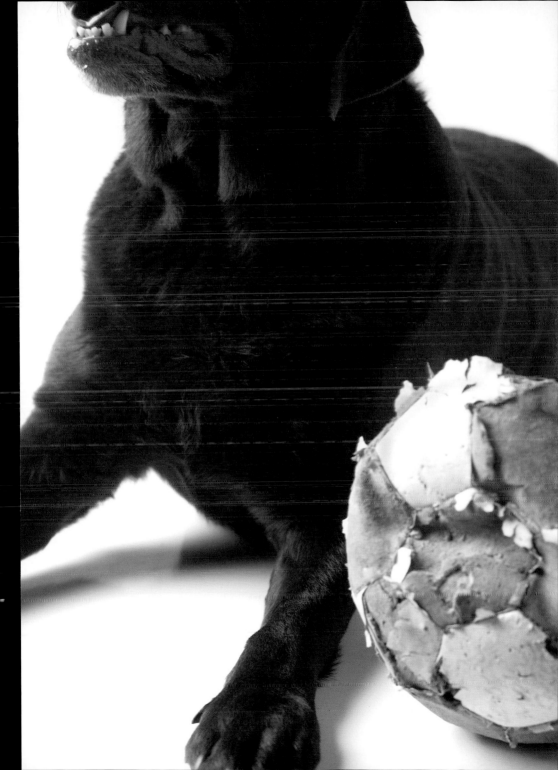

CHILI and Rope

"No tug-of-war and no ropes for this little guy!" was the first instruction from the trainer when the Hemley-Weisberg family brought little Chili to puppy obedience class. More than a little chagrined that their cockapoo had pranced in with his most beloved possession—the aforementioned rope—clamped proudly and intractably in his youthful jaws, the Hemley-Weisbergs promised to find a substitute toy. But, like most youngsters, Chili had a mind of his own. And like most dog-loving families, the Hemley-Weisbergs found it hard to resist indulging their puppy in his favorite game. Six years and many ropes later, Chili Hemley-Weisberg has trained his family well.

Cockapoo

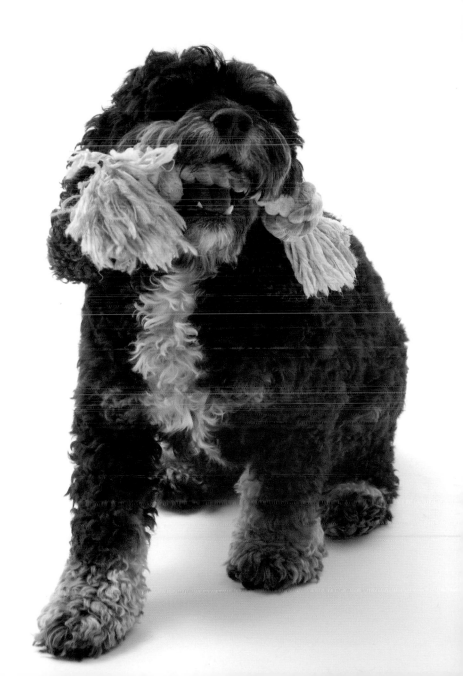

CHLOE
and one of her many balls

\mathcal{H}ow does she do it? How does Chloe make the ball levitate? Is it Bernoulli's principal at work? Houdini-like concentration? Is she a disciple of David Blaine? Or a student of transcendental meditation? The goldendoodle (a cross between a golden retriever and a poodle) loves to learn and has an energetic, fun-loving disposition—hallmarks of both breeds. So maybe it's just the sheer magic of Chloe's inherent good nature and indefatigable charm that allows such a trick. Or, perhaps, more clever than anyone could imagine, Chloe has trained her people, teaching them to toss her favorite ball right on cue.

Goldendoodle

CIRCE and Gorilla

In Greek mythology, Circe, daughter of the sun, was a sorceress who was able to turn men into animals. Circe's house was filled with lions and wolves, drugged victims that were once human. With her superb knowledge of magical potions, she even turned Odysseus's shipwrecked crew into pigs, leaving us to wonder just what *this* Circe's beloved Gorilla once was. Like her mythological namesake, Circe the coonhound also has a menagerie, albeit hers are plush animals that are kept in a basket by the back door for those rare occasions when she gets tired of the toy now known as Gorilla.

Redbone Coonhound

28

CK and Sock Monkey

\mathscr{C}K lives with Joey, a soft-coated wheaten terrier. Eighteen months after bringing CK home, Michael grew concerned. CK's breed typically has a silvery blue coat that should have complemented Joey's wheat-colored coat, but not match it. But match they do—so much so that everybody assumes that they are related. Last Christmas, Michael's wife, Martha, decided to take action. On Christmas Eve, armed with a big brush and a weak solution of blue food coloring, Martha transformed CK, if only for a day or two, into a bluer Kerry blue than even Michael had in mind. Truth be told, the result was rather greener than Martha expected, but it turned out to be the Christmas gift that kept on giving because Michael has never mentioned CK's unusual coloring again.

Kerry Blue Terrier

CODY and Blankie

*W*ith his large, almond-shaped eyes, expertly ringed with eyeliner, and long elegant neck, it seems as if Cody is channeling Audrey Hepburn's character Holly Golightly in *Breakfast at Tiffany's*. It's not just his graceful stance, slender physique, and seductive glance that conjure the actress. Cody's sleek fur matches his blanket and is reminiscent of the stylish ensembles that the always perfectly attired Hepburn wore in the movie. But despite being secure in his good looks, Cody's not that different from the rest of us. Sucking the corners of Blankie when he's tired and it's time for bed reminds us that no one is too sophisticated for a security blanket now and again.

Whippet

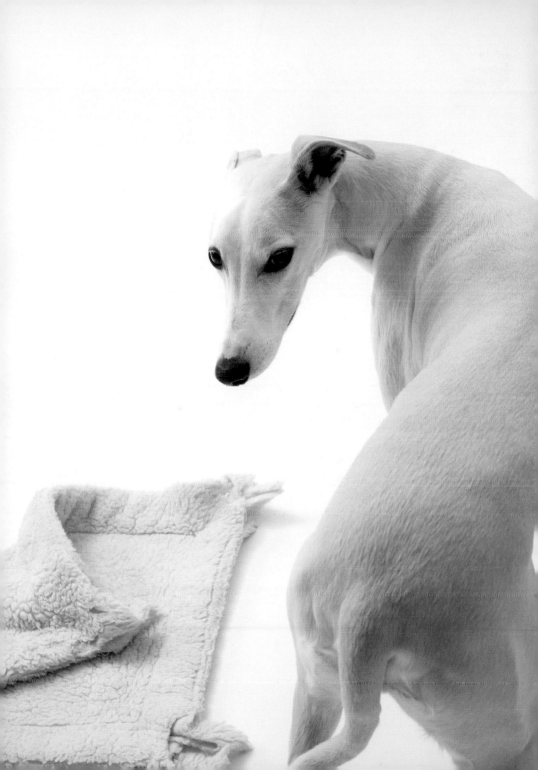

DAISY and Stick

A Southern girl, Daisy has plenty of charm, lovely manners, and confidence. Added to that is her environmentally friendly policy of going green—even in her choice of toys. This is one eco-conscience and thoughtful young lady. Daisy knows what's important in life (and for the planet). Her attraction to recycled wooden treasures (sticks)—whether to use for a rousing game of fetch or in a more contemplative way when she meditates on the meaning of bark—are enough to keep Daisy content while keeping her carbon paw-print admirably dainty.

Mixed Breed

DEE DEE and Yellow Ball

*O*ne of Dee Dee's favorite activities is her own signature version of tug-of-war. Here's the game: Dee Dee approaches with her now scuzzy yellow, squeaking ball. She has several fresh, clean ones, but they are of no interest to her. Once she engages you and you actually take hold of the matted, spitty sphere, she melts your heart (and your resistance) with those enormous, liquid eyes. Dee Dee triumphantly seizes Yellow Ball, squeaks it like mad, and runs away to hide it in the laundry basket (preferably filled with laundry). Game over. Until Dee Dee returns a minute later with Yellow Ball, using those pleading eyes to cajole you into losing just one more time.

Italian Greyhound

DELLA and Ring Toss

\mathcal{L}ike most terriers, Australian terriers are known to be high-spirited and self-assured, great traits if, like Della, you're a ring toss champ. In the case of this particular eleven-year-old, another quality is clear: Della has patience, something not often seen in the typical terrier personality. Della's real name is Edwyre Della Bean Hershman-Blunk Blunk-Hershman. If ring toss is your game, imagine having to wait to hear "Edwyre Della Bean Hershman-Blunk Blunk-Hershman, come here!" every time one of your people, be it Hershman or Blunk, is trying to get your attention when it's time to play your favorite game. That's ruff.

Australian Terrier

DEXTER and Fuzzy Blue

*D*o dogs smile? In the dog psychology world the jury is out, but one look at Dexter and it's impossible to believe that they don't. Especially when you consider that Dexter is lucky enough to have Fuzzy Blue as his best friend. The pair share the same traits; they're scruffy, fluffy, sweet, and, well, just happy. Cute as Dexter is, maybe that smile is more devious than we think. Louise reports that one of Dexter's favorite activities is sitting on the back of the couch with Fuzzy Blue peering out the window . . . like a cat. Sure does make you wonder whether what looks like a smile is really a grin—the grin of the Cheshire Cat.

Soft-Coated Wheaten Terrier

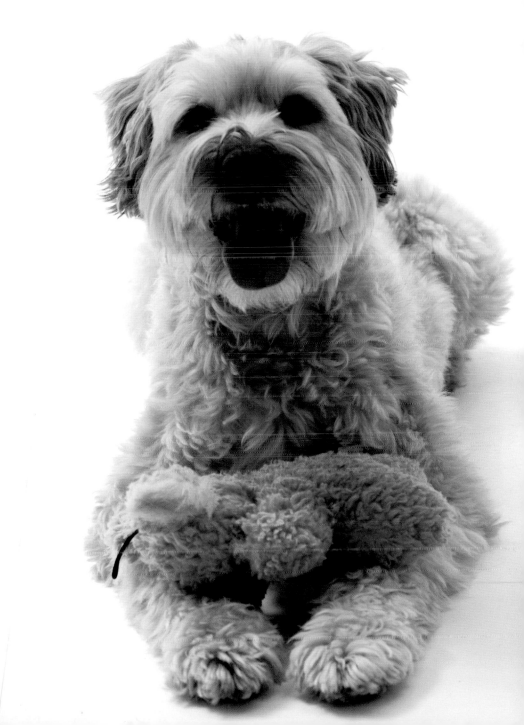

DIESEL and Water Bottle

*M*any dogs will single out one particularly beloved toy to the exclusion of all others. No matter how many other toys are available, or how many fresh, clean versions of the same toy are on hand, there is something about the original that remains especially alluring. This can cause some consternation: What if the toy gets lost? Or is purloined by another dog? A victim of vigorous play? Or it simply disintegrates? Not a problem for Diesel. Perfectly content with almost any old, empty plastic bottle, she does have one requirement: each bottle must have a cap. In fact, for Diesel, half the fun is removing the cap. Yes, she can untwist it, no matter how snuggly it's screwed on. With the current craze for constant hydration, there is surely no dearth of toys to keep Diesel happily occupied—and plastic bottles out of the neighborhood landfill.

French Bulldog

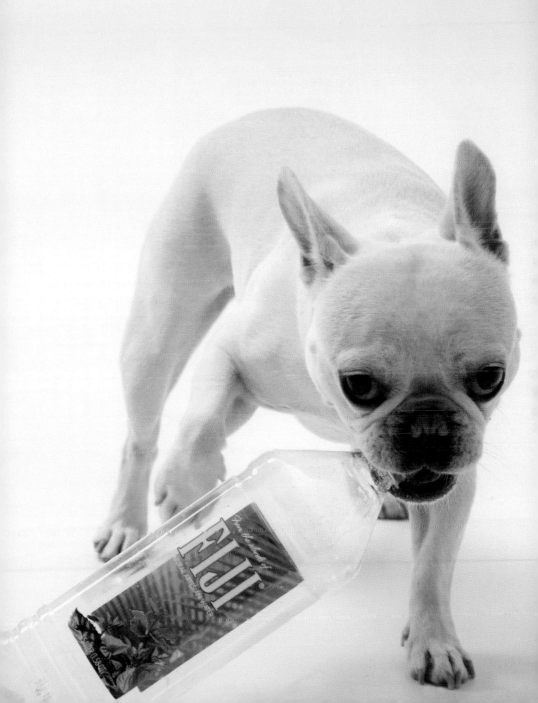

DUBLIN ENNIS and Ropie

*W*hen Patricia told her friends that she was getting a Glen of Imaal terrier, they all assumed, never having heard of this rare Irish breed, that she was getting a "glen-of-the-mall-terrier." No one found this surprising as they all knew how much Patricia loved to shop. What they didn't know was what a good shopping companion Dublin Ennis would make. While some of Dublin's canine friends prefer a jog in the woods, this terrier, with his sturdy body and short legs, enjoys a good brisk walk—and what better place than the mall? More important, with the Glen's typically cocky and high-spirited temperament, Dublin Ennis has just the right traits to spot a good bargain (and nab it) before anyone else.

Glen of Imaal Terrier

FIONA and Bear

*O*ne look at Fiona prancing around with Bear and it's easy to understand why goldens are among the most popular breeds of dog in the world. Even though she's just a puppy, Fiona has already developed some routines, one of which is that at about 10 o'clock at night—every night—Fiona's rambunctious nature gets the best of her and she runs around in circles—literally. She makes a path that starts in the living room, passes through the den, cuts through the dining room, and starts again in the living room. Round and round she goes with Bear at the helm. The fact that Bear is almost exactly the same color and sheen as Fiona makes it hard to tell where Fiona ends and Bear begins. Much to the delight of Susan and Rich, not only does this evening romp fill the house with a beautiful blond blur, but it concludes with a puppy who is ready for a good night's sleep.

Golden Retriever

HALLE and Frisbee®

*L*ike most four-year-olds, Halle delights in the joys of play, especially when a certain slightly chewed, black Frisbee® Disc is involved. No matter the time of day or night—Halle's been known to wake up from a deep sleep when she hears the word "catch"—she's ready to display not only her good sportsmanship (a result of her Labrador heritage) but also her exceptional agility (part of her poodle pedigree). If it weren't for that fluffy tail, she might make it all the way to the Ultimate Players Association Championships.

Labradoodle

HENRY and Elephant

*T*he first thing Candace did after she brought her new pup, Henry, home to her apartment in Boston was to call her mother in Nashville. Candace couldn't wait to share the good news about Henry's arrival. As if she were a new grandmother, Candace's mom was anxious to send something special for the new puppy, and Elephant arrived shortly after Henry did. The stuffed gray toy shared Henry's bed until the pup was strong enough to tote him around. At first Elephant was bigger than Henry, whose mouth was too small to fit around the toy's middle. But soon, the young pup learned to haul Elephant around by his appendages, which, to this day, is still Henry's favorite method of transport.

Boston Terrier

HURLEY BURLEY
and Iggy Iguana

*I*n portraits, Hurley Burley can seem hoity-toity. There's the Christmas card where he was photographed on a silk sofa in front of rather tall windows that were adorned with heavily fringed drapery. There's another portrait, posted on a website, of Hurley Burley with Tony, who, wearing riding boots, is holding the terrier in one hand and the reins of a horse in the other, a white-fenced paddock just visible in the background. But in reality—and absent the sumptuous city digs or country estate—Hurley Burley is the tenacious, playful, energetic, and affectionate dog that we expect of this breed, trying to tear Iggy to pieces one minute and nuzzling him affectionately the next.

Parson Russell Terrier

ISABELLA and Monkey

*T*hree-year-old Isabella may not be as clever as she seems to be in this picture. Sneaking off the set with Monkey, she appears to be in complete control, but it turns out that this behavior may not be typical. Isabella lives with Christina, an architect. Although Christina's work involves problem solving and mathematical precision, that hasn't rubbed off on Isabella. Monkey's precise geometry (a monkey attached to a circular rope) often baffles poor Isabella. Playful creature that she is, her enthusiasm sometimes gets the best of her as she finds herself hopelessly tangled between Monkey and the rope. Fortunately, Christina is right there to solve Isabella's three-dimensional dilemma.

Puggle

JAGUAR and Monkey

*T*here is a statue of Balto, a Siberian Husky, in New York's Central Park. It commemorates a 600-mile journey in Alaska, in 1925, when a mush team, lead by Balto delivered serum to the children of Nome who were in the path of a deadly epidemic. The dedication on the statue ends with three words: "Endurance, Fidelity, Intelligence." Jaguar exhibits similar traits, at least to Sarah, albeit it on a reduced scale. To wit, Jaguar's endurance begins at 11 P.M. every evening when he runs in circles through the house for what seems like hours. Jaguar's fidelity is clearly evident in his devotion to Monkey, whom he always runs with. As for his intelligence, let's just say that he knew enough to leave Monkey intact, Jaguar's only toy that still possesses its squeaker.

Siberian Husky

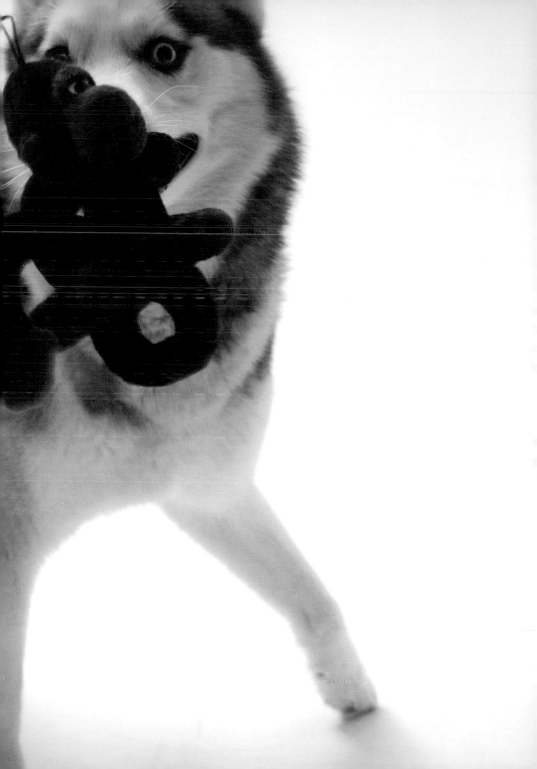

KANO and Soccer Ball

*R*honda is proud of her dog's athletic prowess. She's not being boastful, it's just that she knows canines. As the manager of a dog-walking service, she meets a lot of them, and she's come to realize that Kano is a real jock. He's not particular about his sport and is just as happy playing with a football, basketball, or a soccer ball. Kano's devotion to sports should come as no surprise, his breed is known for the same traits that makes a good athlete: energy, strength, fearlessness, and perhaps the most important trait of an athlete, loyalty. What more could a teammate want?

German Shepherd Dog

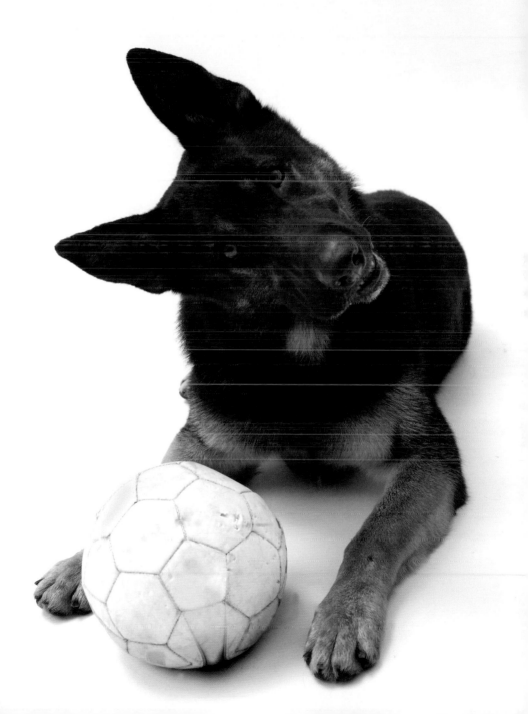

LEO and T-Bone

*A*ffectionately known as Swissies, these large dogs are often mistaken for other European working breeds. To the uninformed, Leo is frequently misidentified as his more famous cousin, the Saint Bernard. But unlike the Saint, which was used for mountain rescue work, the Swissy's size and strength made it useful for hauling farm carts loaded with produce and dairy. Leo, however, hauls nothing heavier than T-Bone, a plush pheasant. These working dogs are also known for their herding skills, which makes Leo's attachment to T-Bone—carrying the bird in his mouth so it looks like his latest retrieval—a bit of an anomaly among fellow Swissies.

Greater Swiss Mountain Dog

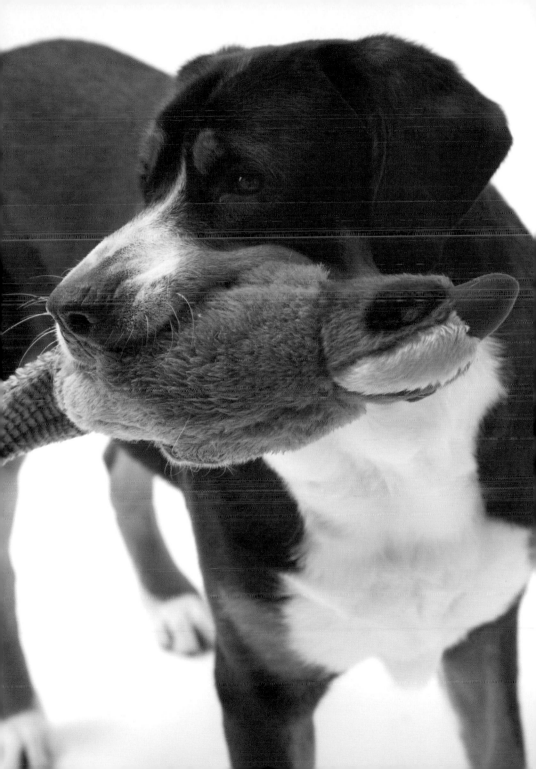

LEXIE and Lambie

*W*ith a few idle minutes to spare one day, Marianne was perusing the newspaper when she spotted an ad for a standard poodle. Not intending to share her home with a dog at that particular time, Marianne was nevertheless intrigued by the description and phoned the number listed. The man who had placed the ad in search of a new home for his beloved pet had received over one hundred calls and invited twenty of the responders to meet Lexie. Marianne was one of them. After narrowing the pool of prospective homes down to five, the man then visited each of them. Marianne and her family were the lucky recipients. There was, however, one requirement: each year, on the anniversary of her adoption, the man requested that Lexie be fed a steak dinner. A small request for such a large gift.

Standard Poodle

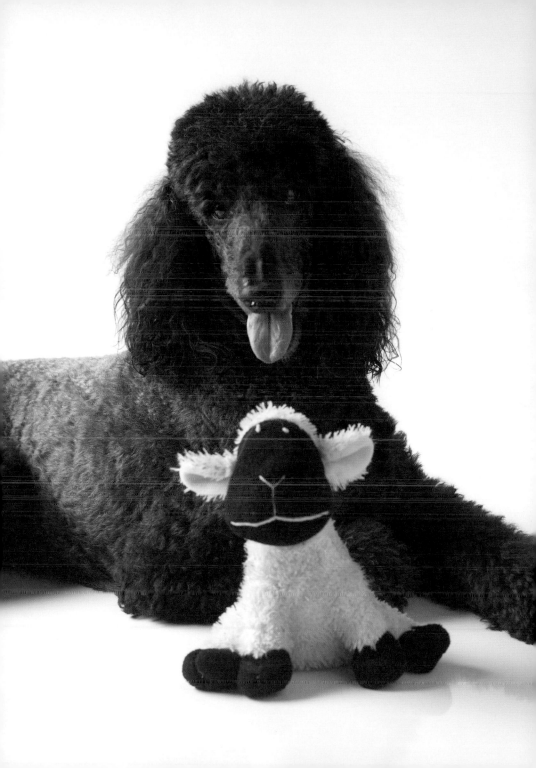

LOLA and Cherry Pie

\mathcal{T}he good-natured Lola lives with her equally beautiful soul-sibling, Shiloh, also a Rhodesian ridgeback. Though Lola is outgoing and engaging and Shiloh more aloof, the two of them walking down the street with Shannon and Jeff make a very impressive group. The pair of beauties attracts a lot of attention in the form of petting and baby talk and an occasional treat. It seems that what Lola really wants—once she's sated with Cherry Pie—is a family outing. If it's a temperate New England evening, it's what she usually gets.

Rhodesian Ridgeback

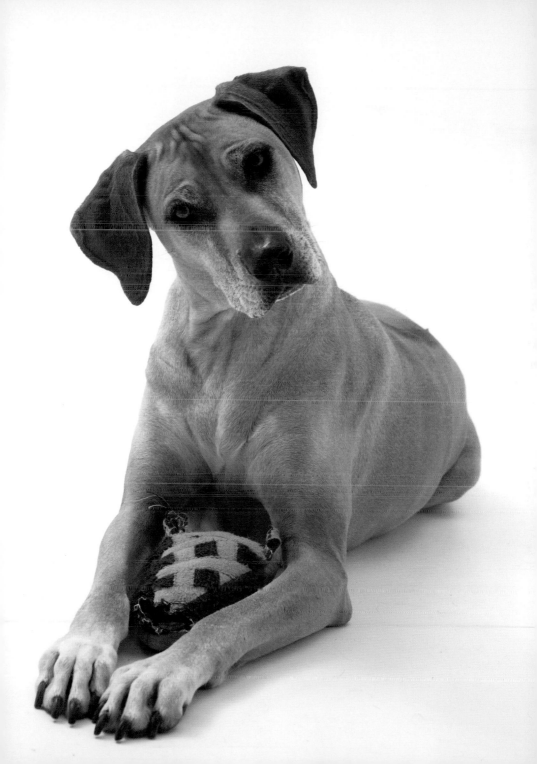

LUCY with Doggie

*W*hen Lucy was given Doggie she knew she had met her match. This sweet-tempered, curious, and energetic puggle loves playing with her alter ego around the house and out in the yard where they cavort until dusk. Lucy and Doggie even share similar physical traits: a thickset body, short hair, and more than a few wrinkles. As for Lucy's droopy ears, well, at one point they did have that in common as well. But Lucy, who loves to nibble, left Doggie earless. This didn't bother Doggie though and the two continue to see eye to eye.

Puggle

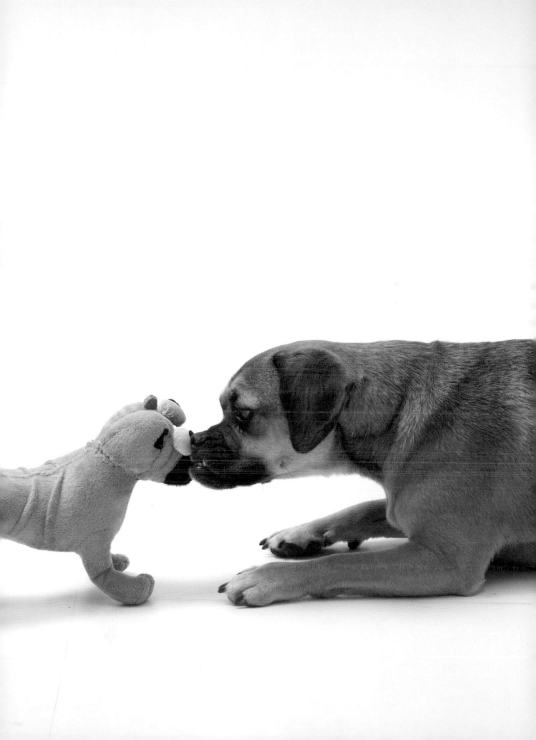

LULU RAE and Chunky Junior

*L*ulu Rae lives with Kimberley and a menagerie that includes three dogs, four cats, two dwarf hamsters, and one sugar glider, which is a tiny Tasmanian possum. No stranger to drawing attention, Lulu Rae's small size and cute good looks ensure that wherever she goes, a crowd of children usually follows. So what's a popular girl to do for a little down time? Lulu Rae's beloved Chunky Junior has a hidden pouch filled with nutshells, perhaps discarded by one of her multiple housemates. Kimberly pops Chunky into the microwave (only on a low setting, please!), then pulls her out so Lulu Rae can snuggle up for a few minutes in the warmth, and the rest of her crowded world disappears.

Long-Haired Chihuahua

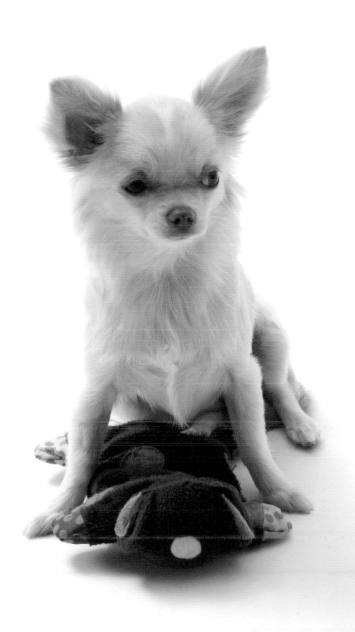

MALIBU and Pink Pig

*M*alibu was three months old in August of 2005 when Hurricane Katrina ripped through Louisiana. Like many other animals, Malibu was left orphaned and homeless until a group of rescue workers brought her to Massachusetts. As good fortune would have it, she finally landed at the Animal Rescue League of Boston where Ashley works. As Ashley tells it, when anyone at the Rescue League was having a bad day they visited Malibu for a "Mali hug." It wasn't long before Ashley - unable to resist the affectionate, sweet dog— adopted Malibu and brought the dog home with her. Pink Pig was a welcome-to-your-new-house gift from Ashley. The stuffed toy was chosen expressly for Malibu. As Ashley observes, "She turns pink whenever happy or excited." Which, since that fateful summer of 2005, is Malibu's usual state of mind.

American Pit Bull Terrier

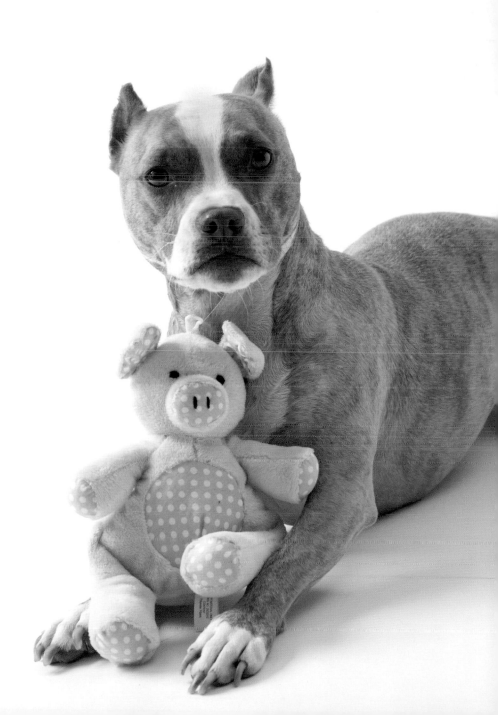

NICKY with Tarzan

*I*t may be hard to imagine that Nicky, with his flowing double coat, regal carriage, and reputation as the ultimate house pet cherished by Chinese royals for over a thousand years, can be rambunctious. But as Janet reports, Nicky is not content to just sit around and look pretty. Contrary to typical Shih Tzu behavior, he needs more than a little exercise. Hence, Tarzan, a yellow rubber monkey, is the perfect companion for Nicky. Flinging Tarzan into the air, playing tug-of-war with the monkey's stretchy limbs, or dragging him through the house, Nicky never tires of his favorite plaything.

Shih Tzu

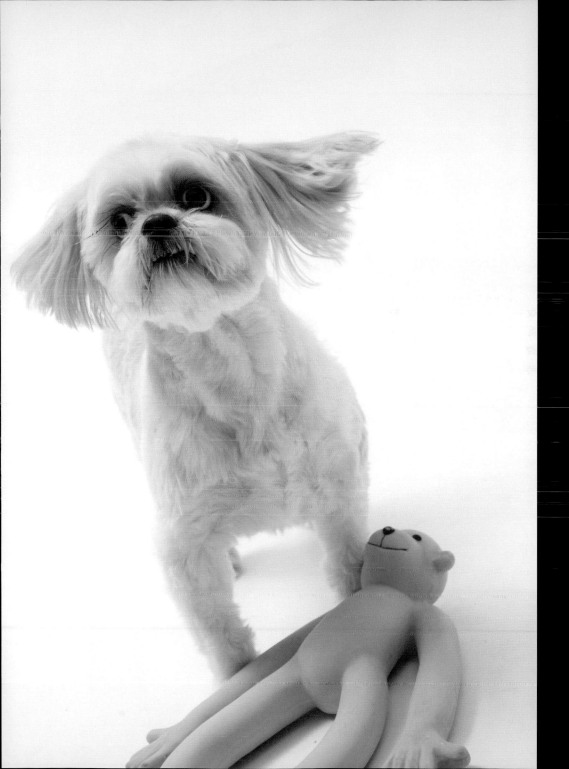

NILOU and Tennis Ball

*T*hough pure of color and spirit, and despite her compact size, Nilou's no pushover. The seven-year-old Westie knows how to go after the things she wants. In this case, it's her steadfast companion, a Wilson tennis ball. When not playing tennis, she can be found at a grade school in Cambridge, Massachusetts, in the "Office of the Next School Advisor." There she gives support to Jen, helping to insure that the students Jen advises get what they need—good placement.

West Highland White Terrier

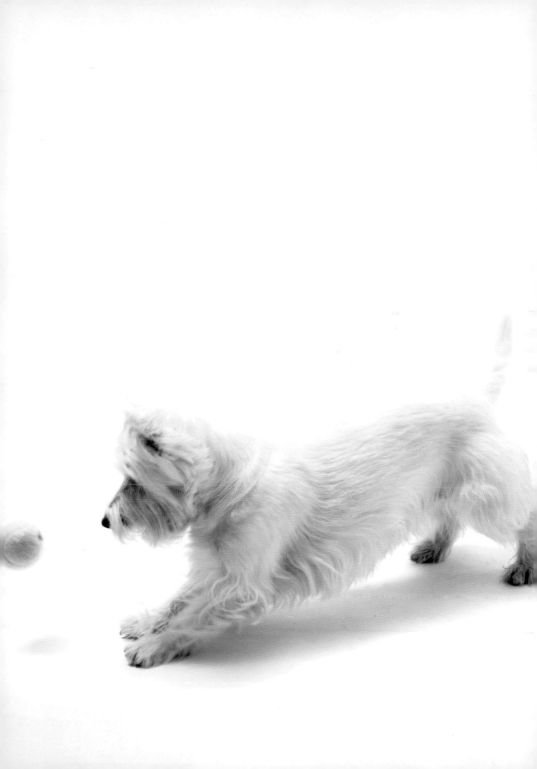

OLLIE and Mr. Man

A large dog, Ollie cuts an elegant figure when he walks into a room. At ten years old, head up, alert, still with a beautiful loping gait, Ollie appears wise and sophisticated, even a bit aloof. That is, until Mr. Man is around. Though Ollie has had Mr. Man for five years and they play together a lot, Ollie never tires of cavorting with his favorite toy, gleefully tossing him around. Ollie is far more gentle with Mr. Man than he is with some of his other playthings, but Mr. Man still needs a few stitches on occasion to keep him in tip-top shape and ready for what Ollie likes best, snuggling as if he were a pup again.

Gordon Setter

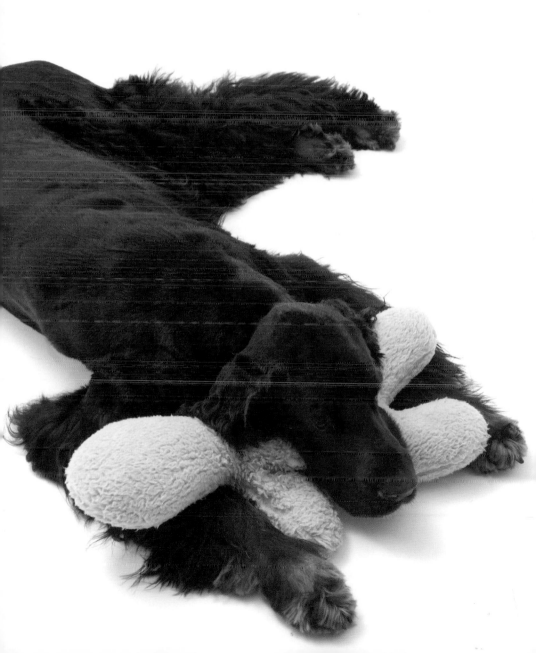

OSCAR and Blue Bear

\mathcal{O}scar lives in a stylish loft in Boston with Tim and David. Most days you can find Oscar at David's architectural firm, Hacin + Associates, where his duties include standing sentry over design details, protecting the office from intruders, and indulging the staff in an occasional game of fetch. If this is not responsibility enough, Oscar is also a vocal advocate for his neighborhood's dog park. Oscar carries out his responsibilities with impeccable manners and an elegant reserve. But even with all this professional élan, Blue Bear is still a powerful force in Oscar's life, a seductive enough playmate to revert Oscar to his life as a dog. One toss of Blue Bear is enough to sweep Oscar off his feet.

Miniature Schnauzer

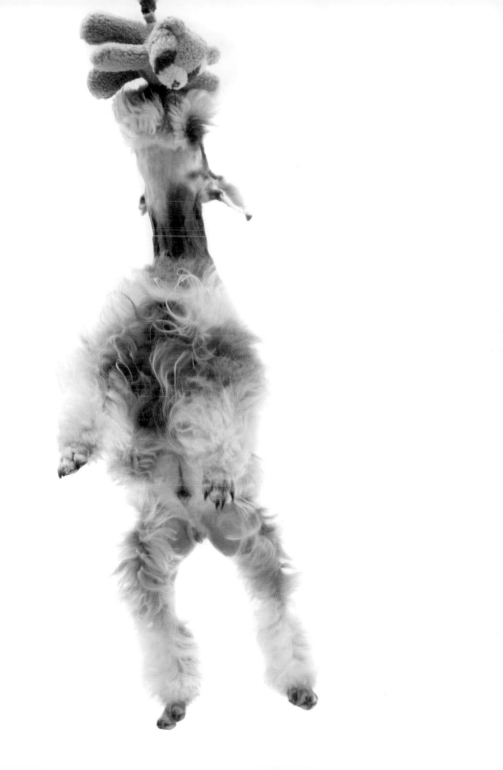

OTTO and Blue Toy

*I*s he blue? Well, that all depends on your point of view. Otto is a blue weimaraner, but the American Kennel Club considers that a flaw and would disqualify this handsome fellow from the show ring. But that doesn't make him sad. For starters, Otto knows he's good-looking. He's also a good swimmer thanks to his webbed feet. And, he's proud of his heritage, which in the United States dates back to 1949 when Captain Henry Holt brought Cäsar von Gaiberg ("Tell") from Germany. And Otto does have a propensity for the color blue, as evidenced by the way he protects Blue Toy, who's even bluer than Otto. Wonder what the AKC would make of *that*?

Blue Weimaraner

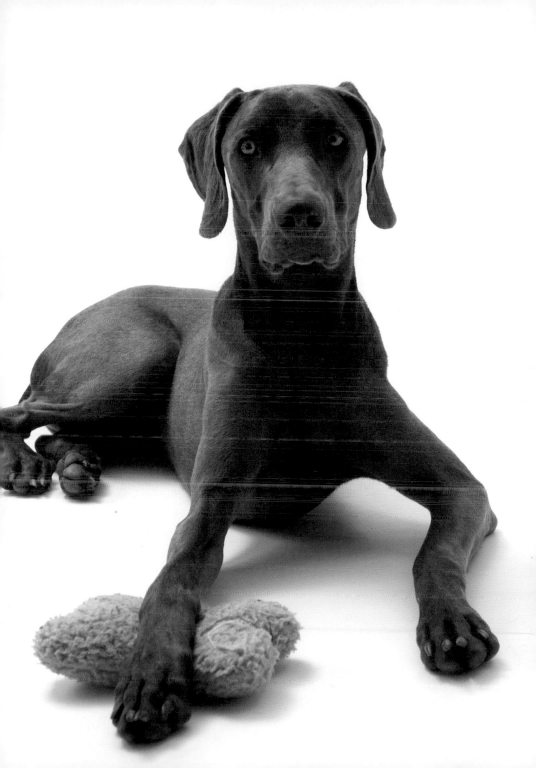

PEPPER and Pink Elephant

\mathcal{T}hough excited to be leaving for college in Vermont, Savy worried that she would miss her grandmother's dog, Pepper, who lives in New Hampshire. Having spent so much time together, Savy wondered how she and Pepper would stay close even when they were living apart. As luck would have it, before Savy left for school, Pepper was playing his usual games with his pachyderm pal, when he accidentally dislodged one of Pink Elephant's legs. Rather than mourn the mishap, the ever-optimistic Savy took it as a good omen, tucked the plush appendage into her pocket, and took it with her to Vermont.

Schnoodle

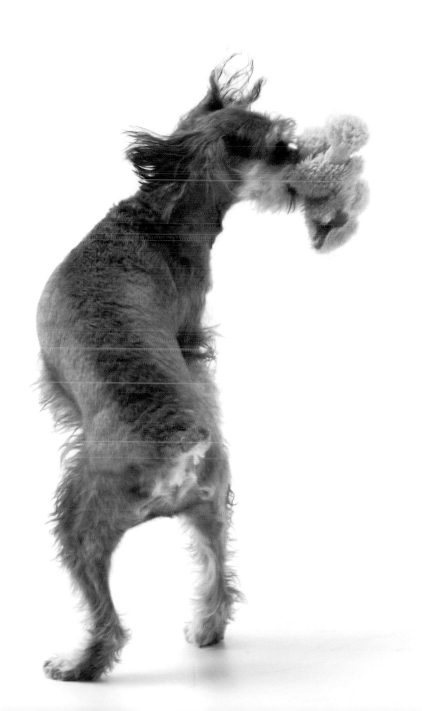

RIO with Bottle

*B*ottle was Rio's very first toy. Originally a plush toy for a human baby, Bottle "talks," repeating "It's a boy!" whenever it is shaken. Some might have found these exhortations annoying, but not Rio's family. As a puppy, the Portuguese water dog was in perpetual motion, racing from room to room throughout the Berenberg-Wilstein household with the talking toy in his mouth. Bottle's constant refrain came in handy by keeping family members abreast of Rio's whereabouts. Five years later, Rio has calmed down and Bottle no longer talks. But that doesn't stop this pair—it just makes them a little harder to find.

Portuguese Water Dog

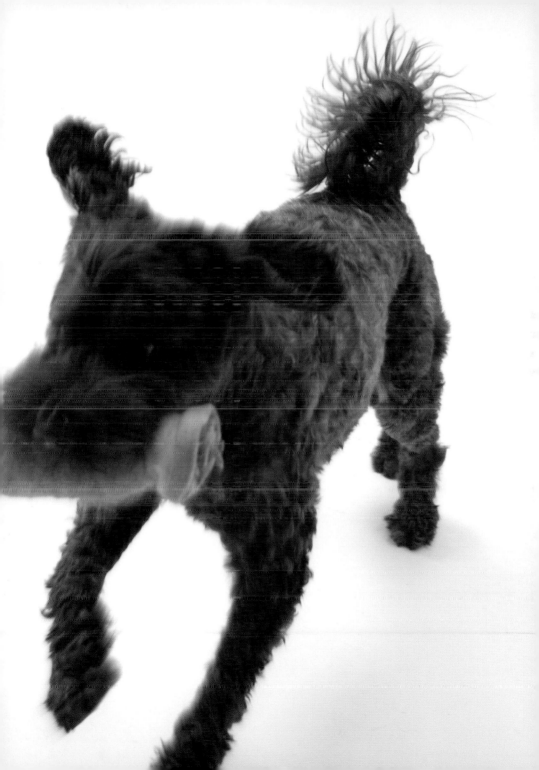

ROSALEEN with Paper Towels

*B*alls and toys hold no particular interest for Rosaleen. Paper towels are her passion because at twelve years old, Rosaleen still holds the memory of kitchen conquests from her younger days when she lived with Peter. A typical teenager, his fondness for peanut butter sandwiches was only matched by his love of sports. Occasionally, Peter would make a sandwich and absent-mindedly leave it on the counter while he went to check the score of a Red Sox game on TV. He would return to find that the only thing left of his lunch were some bits of paper towel on the floor. Even though Peter is now grown up and hasn't left a meal unattended for years, Rosaleen still enjoys a romp with a roll of paper towels and remains ever-hopeful that one more delectable peanut butter sandwich might come her way.

Irish Terrier

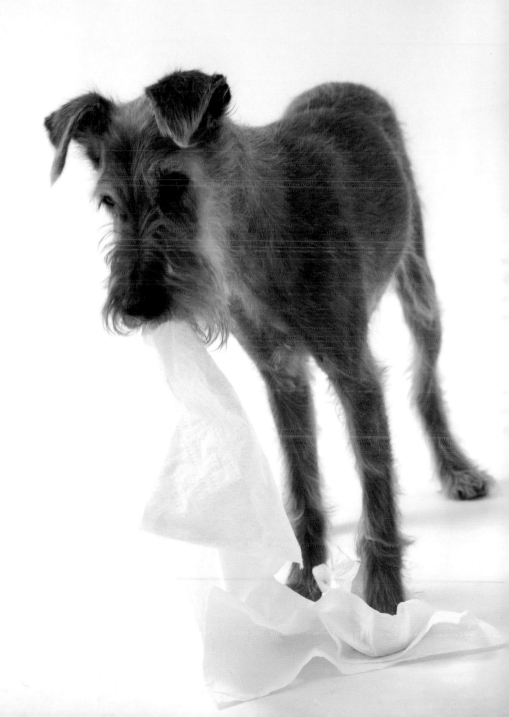

SADIE with Blue Mush

*A*side from the fact that Sadie is a twelve-year-old rescue dog from Puerto Rico, Marie doesn't know much else about her. When asked to describe her beloved pet, Marie calls her a "Cherrier," explaining that she suspects that Sadie is a Chihuahua-terrier mix. When asked if Sadie could be photographed for this book, Marie thought Sadie might be a bit skittish. Marie understands Sadie's hesitation about having her picture taken. A professional food stylist, Marie has spent much of her career getting everything from French fries to foie gras looking just right for the camera. But Marie had no need to worry. Sadie cooperated beautifully. Unlike the perfect scoop of ice cream waiting to be photographed, under the hot lights, Sadie showed no hint of a melt down.

Mixed Breed

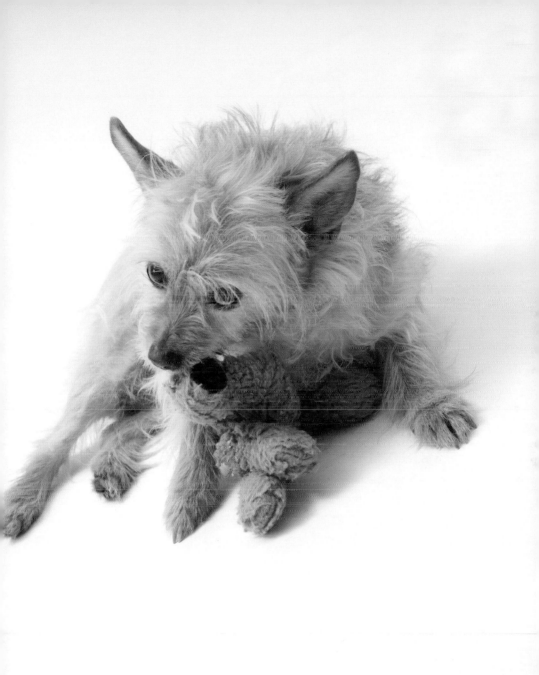

SEAMUS and Bucky

\mathcal{B}ecause of their intelligence, reliability, and versatility, golden retrievers have long been celebrated as fine search-and-rescue workers. In fact, it was just this trait that enabled Seamus to save a stray dog. On the lam from an animal shelter in Brooklyn, the runaway arrived in Seamus's hometown of Lenox, Massachusetts, cold and pitifully thin. Barack (as the stray is now called, having won over the hearts of the community) had, at first, hid in the nearby woods, refusing all offerings of food and shelter. One night, Seamus and Fred were taking their regular stroll around the village green when Barack finally ventured out of the woods, lured by the prospect of playing with sweet, gentle Seamus, a dog he seemed to instinctively trust. Today, thanks to Seamus, all three live happily together under one roof.

Golden Retriever

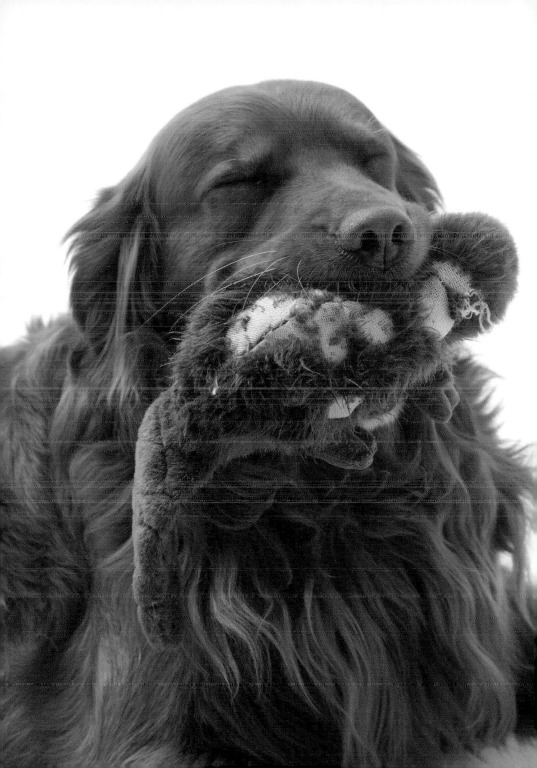

SPRAY and Bear

*I*f we had been shooting a movie rather than a still photograph, the theme from *The Pink Panther* might have been playing in the background. We watched, perched on the edge of our seats, as Spray stealthily herded her beloved Bear from one room to another or retrieved it from a hard-to-find spot. These skills can be traced back to her origins when fishermen depended on their clever water dogs to direct schools of fish from one location to another or to locate missing fishing nets. Inspector Clouseau *and* Jacques Cousteau would be proud.

Portuguese Water Dog

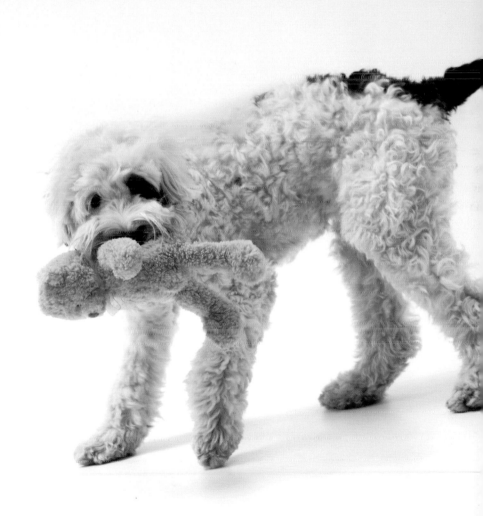

STANLEY and Pinkie Lee

*N*ancie likes to say that Stanley's gifted, one of a kind, a cross between a terrier and a gerbil. Though Nancie jokes about the dog's breeding, Stanley *is* special. For instance, he's unusually selective about his choice of toys, often deliberating for long stretches of time before deciding on a plaything, except in the case of Pinkie Lee, who Stanley prefers over all the others. Nancie suspects that Stanley is so attached to Pinkie Lee because it's rare for Stanley to find someone his own size to play with. There's no denying that the two make a unique pair.

Mixed Breed

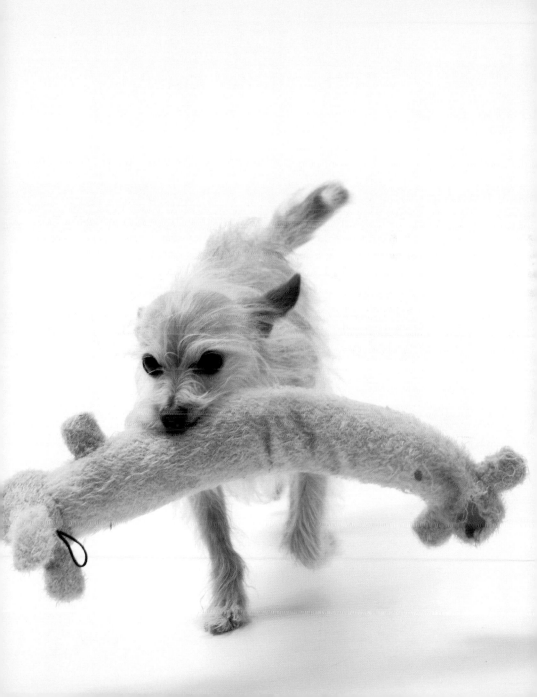

STARK and Blue Box

*T*he small Munsterlander is the modern descendent of a very old German breed. Stark's fine pedigree may be a clue to her champagne tastes. Though she admits to running each day in Boston's Public Garden with other dog friends, some perhaps of less exalted lineage, she demonstrates her good breeding in subtle ways. While her playmates are perfectly happy to chase generic sticks, balls, and stuffed toys—not so Stark. She retrieves nothing less refined than the famous blue box with the perfect white bow.

Small Munsterlander

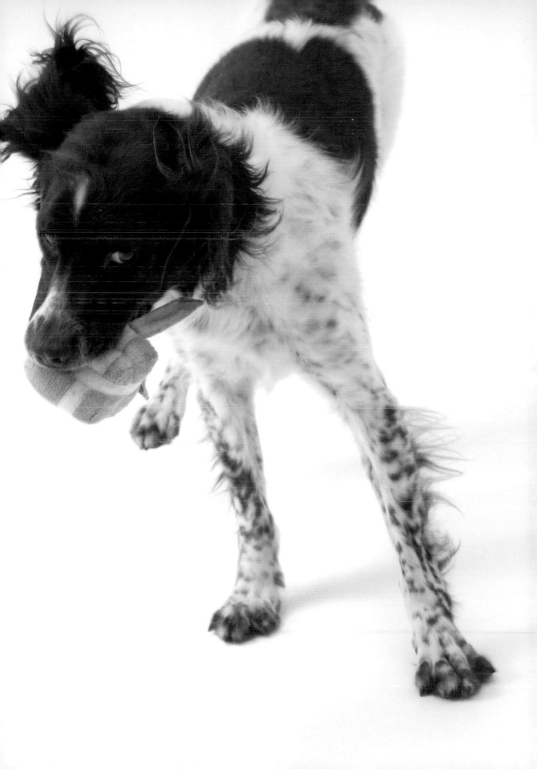

TANK with Squiggle Dog

*S*eventeen-year-old Curt was filling some idle time one evening by surfing the Internet when he came across Tank's story on Petfinders.com. At the time, Curt and his parents weren't looking for any particular breed of dog, in fact they weren't even sure if they wanted a dog at all. But Tank's story—he had been abused and left homeless—stayed with Curt long after he shut down his computer. Always resourceful, and by all accounts more than a little charming, Curt managed to have Tank brought from Florida to Massachusetts on Delta airlines, where even seasoned flight attendants were smitten with Tank's beauty and good nature. Imagine Curt's parents' surprise when, still not sure they even wanted a dog, Tank showed up at the door.

Mixed Breed

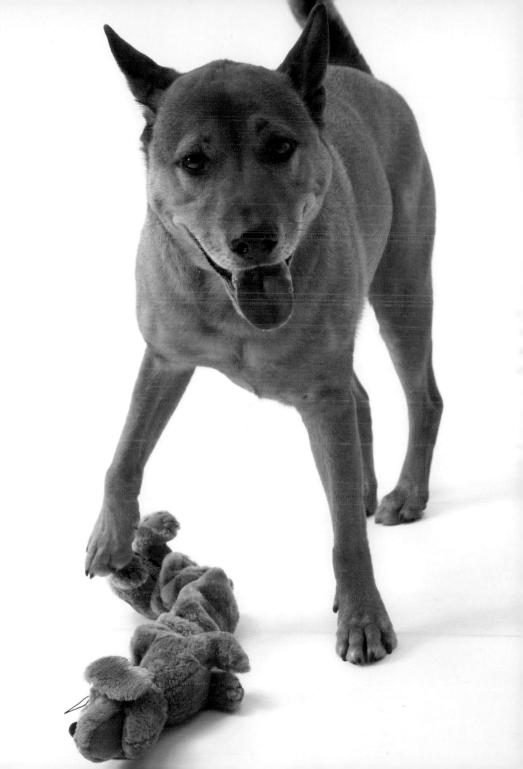

TENZING and Balance Ball

*T*enzing Norgay, the Nepalese Sherpa who was first to reach the summit of Mt. Everest with Sir Edmund Hillary, is the namesake of this happy vizsla. This Tenzing's Everest is to master the balance ball, his favorite toy. For now, he kicks it, nudges it, runs after it, and occasionally deflates it—but who knows? Maybe someday when he's older, he'll manage to balance atop it and reach his own private summit.

Vizsla

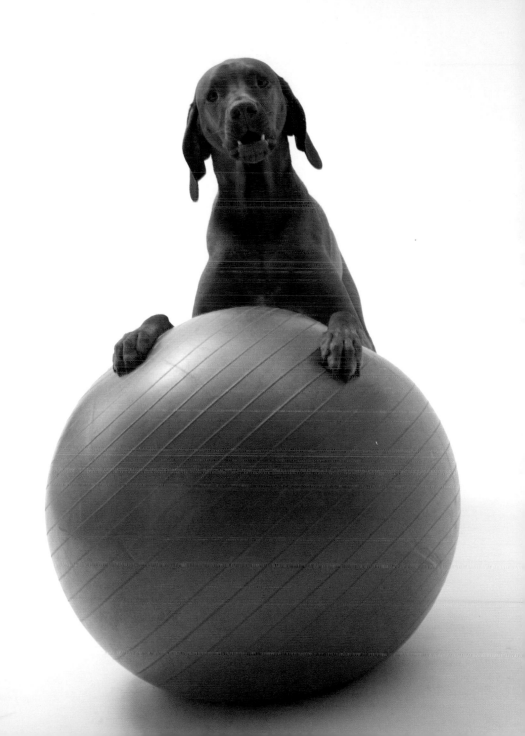

TURBO and Gator

*I*f it's true that opposites attract, there is no better evidence than Gator and Turbo who are an inseparable pair. Gator was Turbo's first Chistmas gift five years ago and the pair have been together ever since, sharing a bed every night. Even when Turbo needs to go out of town, Gator accompanies him. There are others that Turbo cavorts with—a blue ball, a red plastic bone— but for the long term, Turbo is and will always be, Gator's aid.

French Bulldog

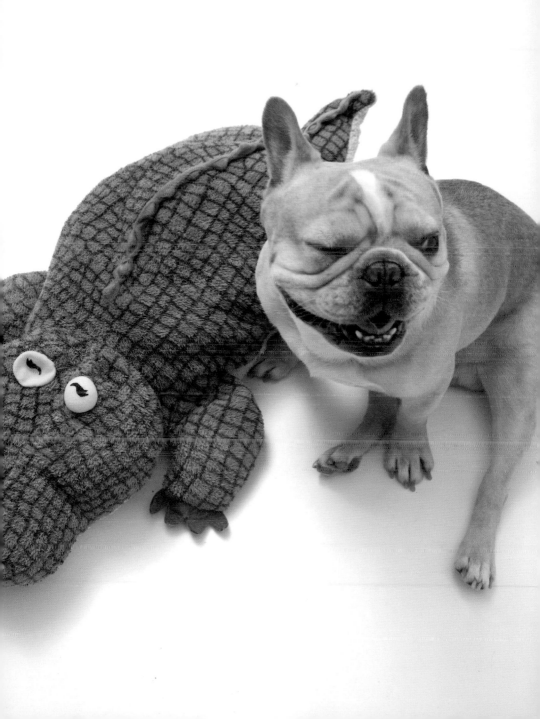

TYLER and Brownie

\mathcal{L}ike most dogs of his breed, Tyler, a bichon frise, is independent, intelligent, and naturally sociable. On occasion, though, when Tyler feels that Dani, the family member he likes best, isn't paying quite enough attention to him, he can get a bit feisty. Tyler's got a reputation for barking as soon as Dani tries to study or have a phone conversation. Whenever this occurs, Dani knows it's time to find Brownie. With Brownie around, Tyler's bark turns into a whisper as he confides his deepest secrets. After all, isn't this what friends are for?

Bichon Frise

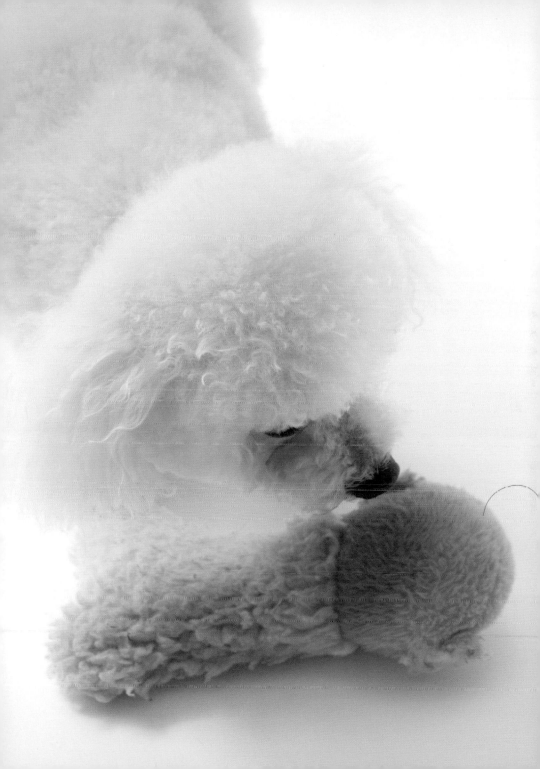

WINSTON and Blue Blankie

*W*inston lives in the city with Quinn, who just turned two years old. The pair can often be seen on the street with Quinn's mom, Nina, pushing Quinn in her stroller while Winston jogs alongside. There are always two blankets in the stroller, a pink one for Quinn and a blue one for Winston when he's ready for a nap. Save for the color, the only other difference between the blankets is how they're used. While Quinn's Pink Blankie keeps her warm as she eagerly watches the world roll by from her stroller, Winston snuggles into the recesses of his soft Blue Blankie making it hard to tell which end of him is buried, his fluffy face or his fluffier tail.

Shih Tzu

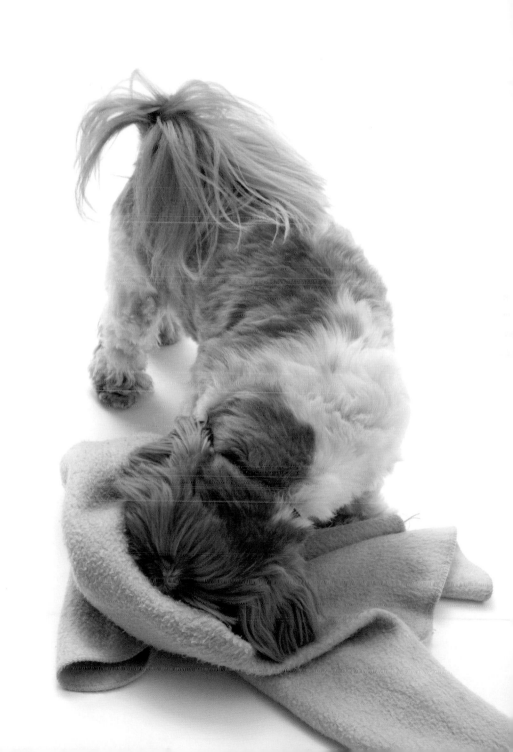

ZEKE and Hedgehog

*O*ver the past thirty years, Nora has had five golden retrievers. Zack was the first, moving in with her shortly after she graduated from college. Abe came next, a wedding gift to Nora and her soon-to-be-husband Jim. When the newlyweds moved to Boston, Zack and Abe accompanied them. Then, Zeus followed Zack, and Amos followed Abe. The most recent addition is Zeke. Of all the retrievers Nora has had, she reports that Zeke is the most rambunctious, running circles around everyone he encounters—including Hedgehog. Even if this photo didn't prove her point, we'd believe her. Nora knows her dog facts—from A to Z.

Golden Retriever

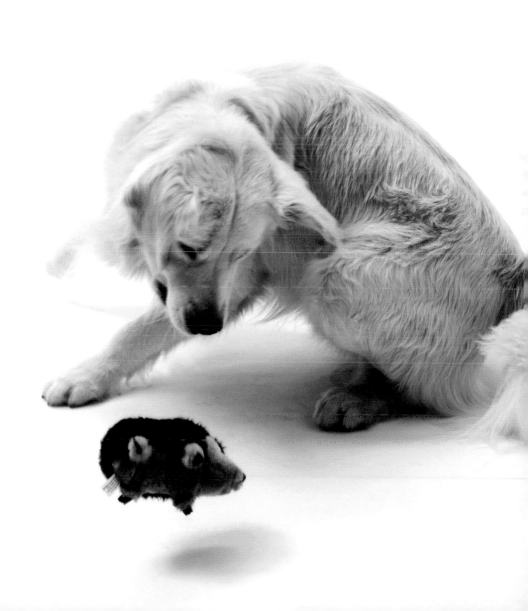

ZOE and Baby Bear

Zoe and Baby Bear are finally together for good and it's all thanks to Grandma. When Pamela first got Zoe, she lived in Massachusetts, her mom lived in Pennsylvania, and they visited each other often. Pamela left Baby Bear at her mom's place so that Zoe would have a friend whenever she stayed at Grandma's. Recently, when Pamela's mom moved to Massachusetts, she brought Baby Bear with her. Now Zoe no longer has to go over the meadow and through the woods to see Grandma or her friend because they're right nearby.

Mixed Breed

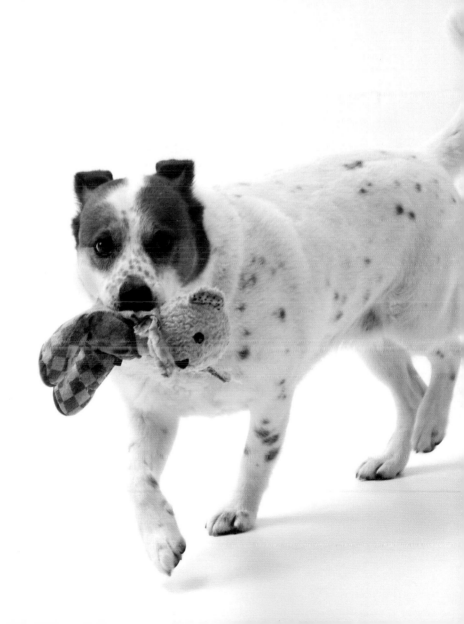